SALT CITY AND ITS ENVIRONS
photographs

The Bear Book
Readings in the History and Evolution of a Gay Male Subculture

The Bear Book II
Further Readings in the History and Evolution of a Gay Male Subculture

Resilience
*A Polemical Memoir of AIDS, Bears, and F*cking*

SALT CITY AND ITS ENVIRONS
photographs

LES K. WRIGHT

Bearskin Lodge Press
Syracuse, NY

In memory of my maternal grandmother
Lillian Hackbarth Newkirk (1897–1962)

ARTIST STATEMENT
by Les K. Wright

As a fine arts photographer I seek to reveal the "soul beneath the surface" of various environments. I focus on the hidden narrative revealed through composition. Sometimes I draw upon the vast catalog of visual images I've accumulated from a lifetime of studying paintings, photographs, and cinematography. Sometimes I focus on the haunted quality of a setting. Sometimes I compose abstractions from "found images." In all cases I avoid digital manipulation and prefer to let the images speak through the engagement of the viewer.

INTRODUCTION
by Les K. Wright

My passion for doing photography was reignited during the covid pandemic shutdown. I had become an adept amateur photographer in my 20s. In my early 30s I explored becoming a fine arts photographer but could not imagine how I would support myself as an artist. The career I did pursue (a literary scholar and a grassroots gay historian) proved hardly any more lucrative or stable.

When the combination of an elusive job market and unexpectedly divorcing my husband forced me to leave California in 2013, I moved back to central New York, where I had grown up. In the frustratingly slow process of sorting out the next chapter of my life, I began filling my time with day drives, photographing the scenery and places I visited on those trips.

Because I made no local friends in the rural community I was living in, Facebook became my "virtual living room." I posted hundreds of my photos there and developed a large following. In the beginning I made a point of never including people in any of my shots. I was making a statement about my social isolation. It was a long time, perhaps two years, before someone noticed this and asked me if this was intentional.

I then consciously developed this practice into an aesthetic. I found the social isolation and loneliness of my rural isolation also captured the loneliness of the American soul, something students of American culture have repeatedly written about.

Over time this exercise sharpened my eye for composition again. I rediscovered the beauty of upstate New York, unearthed all sorts of out-of-the-way photogenic places, and came to realize and appreciate the surviving artifacts of New York State's central role in the 19th century, the precursor for what California became in the 20th century. Trip after trip revealed to me more and more layers of New York State history. New York has remarkable natural beauty, first celebrated by the Hudson River School of painters. It is filled with little towns and villages, often in very illogical places for a settlement. (This was the result of the state being settled by Revolutionary War soldiers, who were paid with land grants in lieu of the money they had been promised by the bankrupt federal government.)

With the completion of the Erie Canal in 1825, a remarkable engineering wonder for that day, New York became "the Empire State," making it the wealthiest state in the nation, opening the shipping route from the Great Lakes to the Atlantic, making New York City the most important port on the East Coast (something that made no impression on me in junior high school New York State history classes), and sealing the financial good fortunes of cities along the route—Buffalo, Rochester, Syracuse, Utica, and Albany.

The Erie Canal opened the wilderness of western New York to settlement. This coincided with the sudden spread of the Second Great Awakening and related religious and reform movements. Charles Grandison Finney (1792-1875) saw this as a firestorm and named it the "burned-over district." Syracuse itself was excluded, bracketed to the east by Oneida and adjacent counties as all of western New York starting at Seneca Falls, where local resident Elizabeth Cady Stanton helped organize the Seneca Falls Convention, devoted to women's suffrage and rights (1848).

As a result, New York State became the locus of a great deal of social, cultural, spiritual, and political experimentation. The Underground Railroad ran through here. The Oneida Community (including communalism and group marriage) lay just east of Syracuse. Joseph Smith started the Mormon Church in Palmyra (the Hill Cumorah Pageant is still a major tourist attraction).

Soon thereafter, wealthy New York City folk flocked to the Great Adirondack Camps, as vacationing became an upper-class pastime. Saratoga Springs became the preeminent horse-racing town and wealthy skiers flocked to Lake Placid to engage in the new sport of skiing. Niagara Falls became the honeymoon destination of choice.

The shift from agriculture to manufacturing in the post-Civil War era transformed much of the landscape. The post-World War II boom in consumer capitalism resulted in optimistic architecture and the spread of car culture. New York State fell on hard times in the 1970s, transforming its cities into economically depressed, and depressing, rustbelt cities. The cities typically depended on the economic engine of a single manufacture. Gone were General Electric, IBM, Kodak, Carrier, Smith-Corona, and so many other iconic corporations. This resulted in blighted landscapes which now deepen the sense of loss and loneliness. There is a terrible beauty to be found in that.

I have a vast mental catalog of images to draw upon, remembered from a lifetime of studying paintings, photographs, and cinematography (the framing and lighting of scenes in films). Some of those influences are immediately discernable in this book—Edward Hopper's hauntingly lonely American landscapes, cityscapes, and Cape Cod houses; Eugène Atget's nostalgic documentation of a Paris that was rapidly disappearing; the romantic beauty of American landscapes of the Hudson River School; the matter-of-fact realistic presentation of the darker side of urban America; the play of light of Impressionism. In the process of seeing the image in my mind's eye, I have also made minimalist, abstract, and negative space studies.

In 2023 I moved back to Syracuse, the place of my birth and childhood. I currently live on the edge of downtown, two blocks from the hospital where I was born. So much has changed over those 60 years. The 1960s re-urbanization destroyed much of the old beauty of a working-class industrial city. The thriving downtown of my childhood has been replaced with half-deserted streets, empty buildings once home to stores and offices, parking garages now abandoned, and rehabbing efforts only just starting to take hold, such as the Armory Square district. With the recent commitment by the

microchip producer Micron to build a mega-factory complex here and the start of tearing down the disastrous 1960s urban renewal I-81 elevated freeway which runs north-south through the center of the city, diving it in half, there is a new spirit of revitalization, of moving past the rustbelt trap of recent decades. Like many other locals, I see new hope in the blight of our current ruins.

This hope for our future is embodied in the recent revival of one of its old nicknames—Salt City. Syracuse was originally home to the Onondaga (Onoñda'gegá) people, or "People of the Hills," one of the original five nations of the Iroquois Confederacy. Their traditional homelands are in Onondaga and neighboring counties (which my term "environs" in the title refers to). My photos include places beyond central New York, but which include areas which the Five Nations (later, Six Nations) inhabited.

The Onondaga Nation was crucial in forming the Iroquois League. The confederacy model of the Iroquois Nation was studied and admired by the Founding Fathers of the United States. This, along with the Greek model of democracy, is the basis of the structure and governance of the United States. This is a source of great local pride.

European settlers found the local salt marshes of extreme value, at a time when salt was the only means of preserving food. Extracting salt from the marshes was the first industry and Syracuse was built on these salt marches. In my childhood swamps continued to exist in the as yet unbuilt-up corners of the city. Shopping malls and subdivisions now stand where these swamps have been filled in. Some swamps still exist in pockets, recognizable by the stunted growth trees and the watery land they stand in.

Syracuse has had other nicknames along the way. Among them was Central City, when there was a push to locate the state capital in Syracuse. As an important east-west and north-south crossroads in the dead center of the state at the time, local merchants and politicians wanted to capitalize on the potential of its growing economic value. Once again, Syracusans are hoping to see the region regain economic, political, and cultural value and emerge as a post-rustbelt city.

The interplay of past glories and failures with the current hopes and fears situates Syracuse in T.S. Eliot's April—"April is the cruelest month, breeding/Lilacs out of the dead land, mixing/Memory and desire, stirring/Dull roots with spring rain." I hope I have succeeded in communicating the interplay between the outer world and the inner world.

Syracuse, New York, March 1, 2024

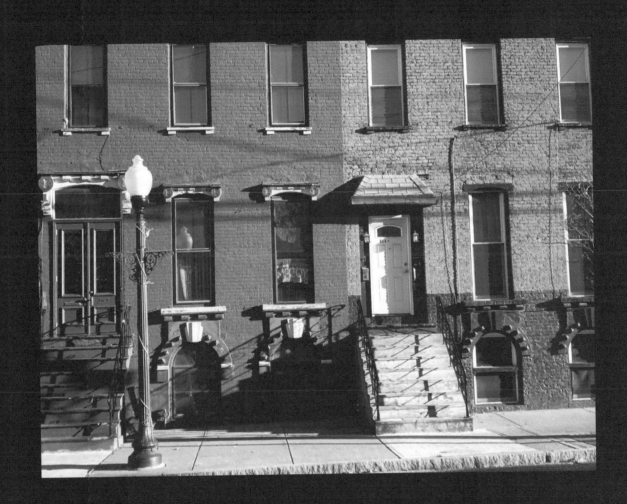

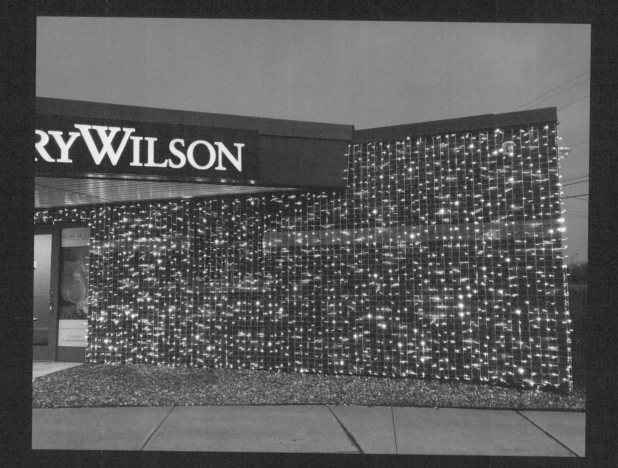

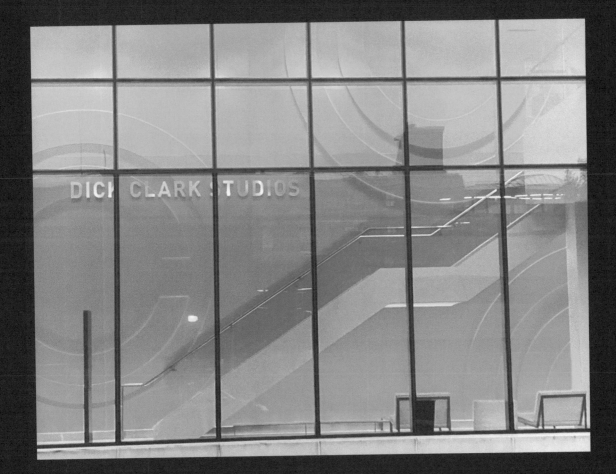

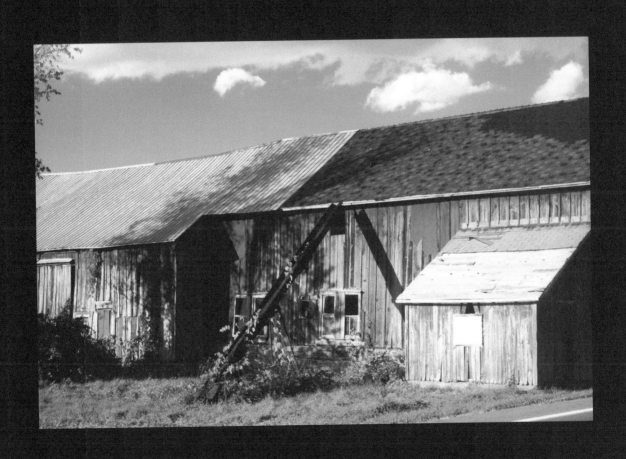

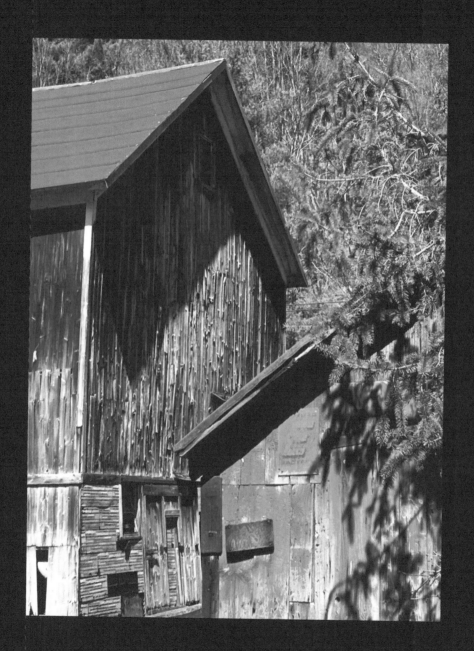

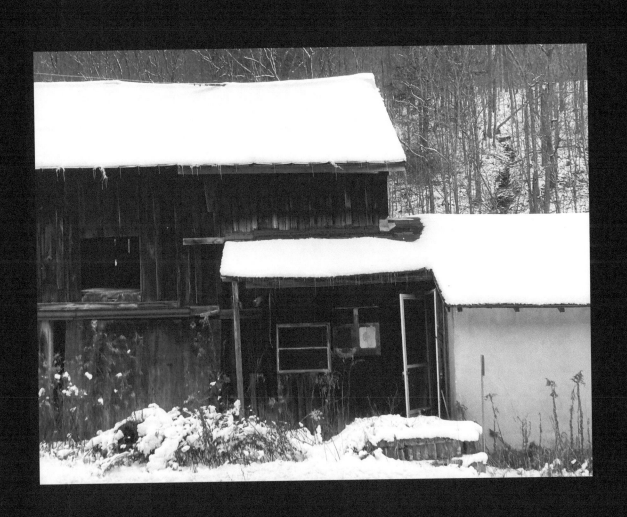

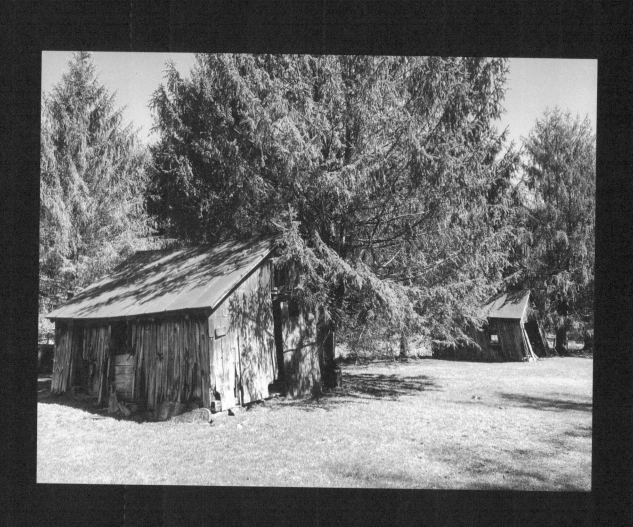

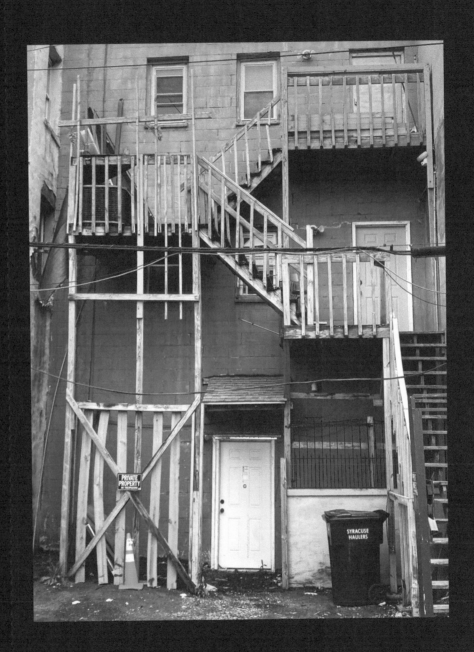

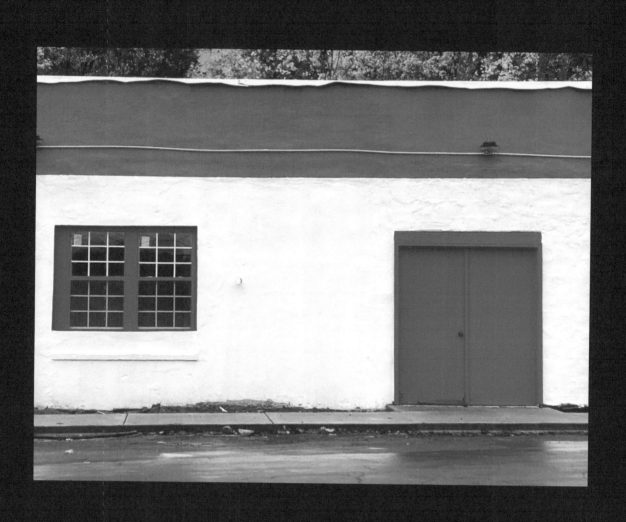

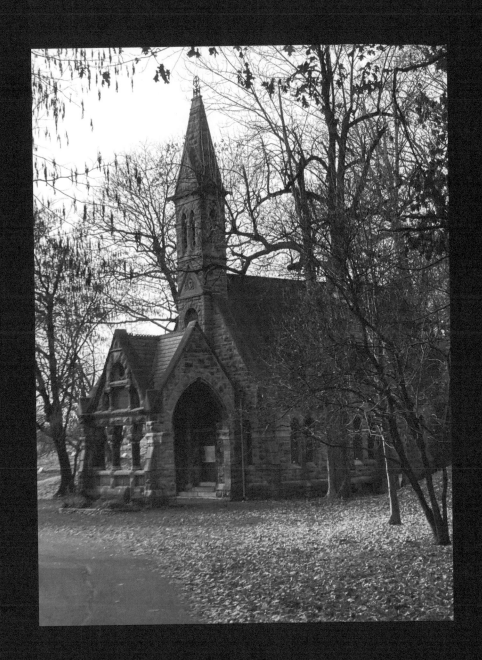

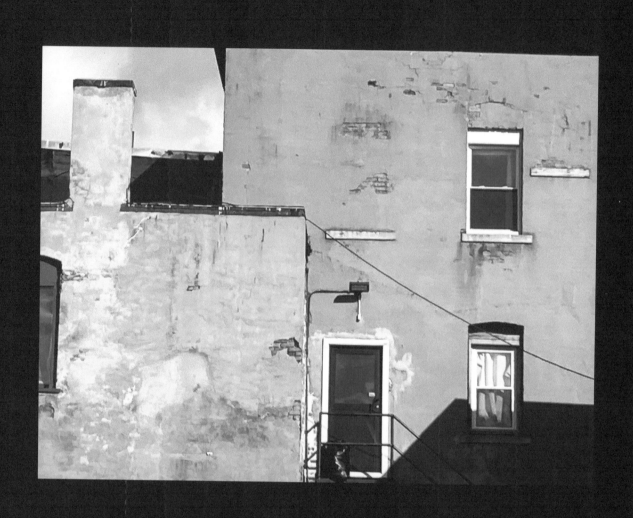

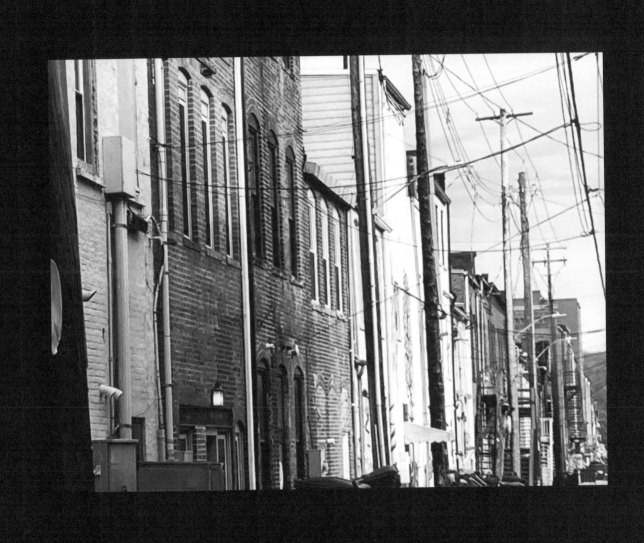

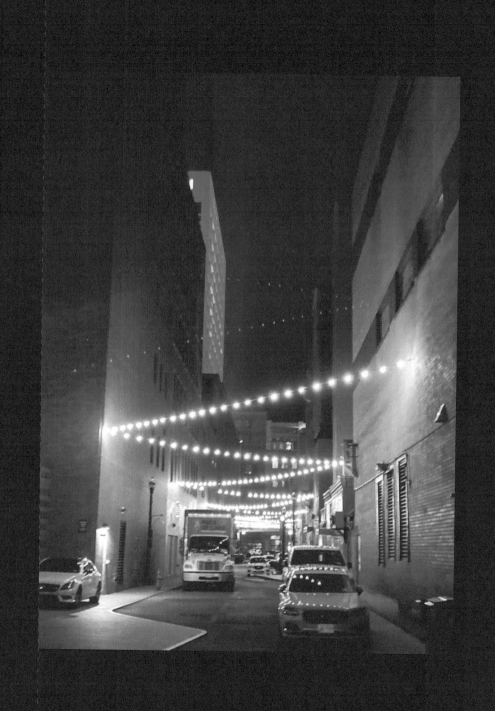

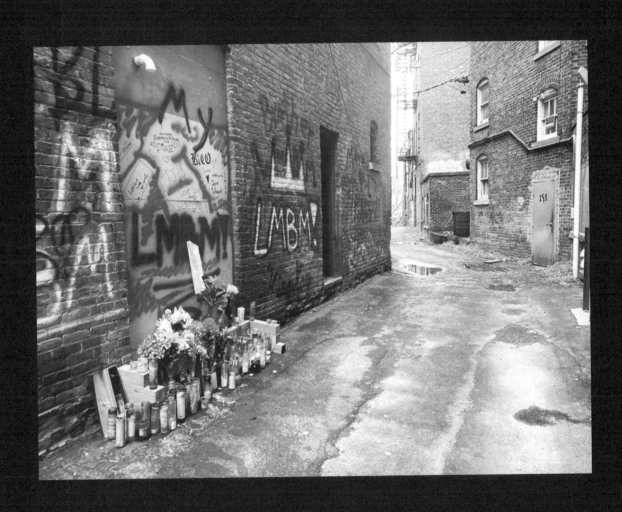

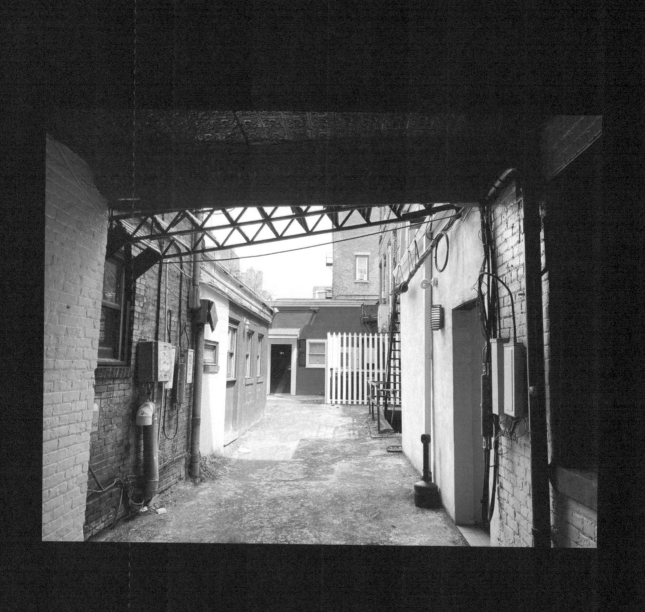

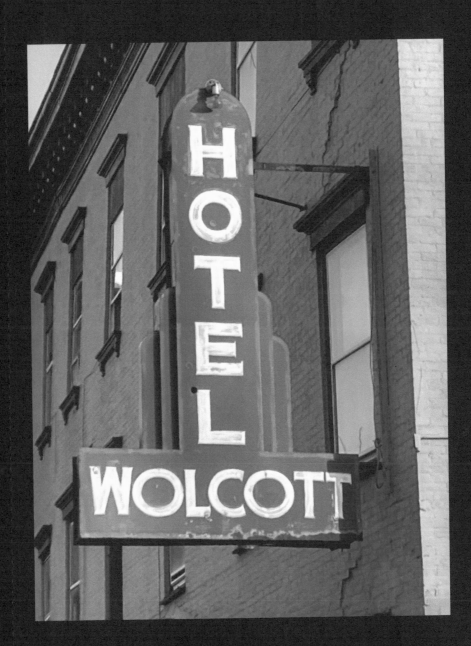

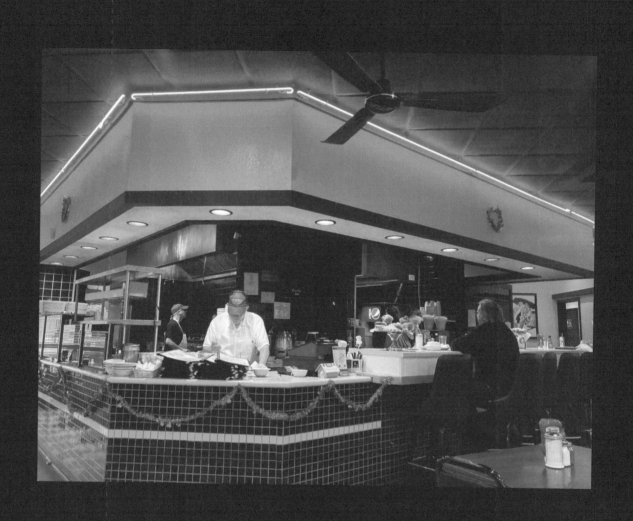

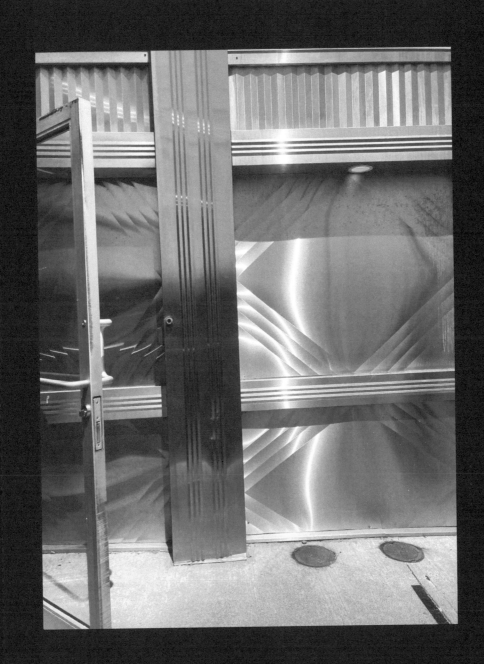

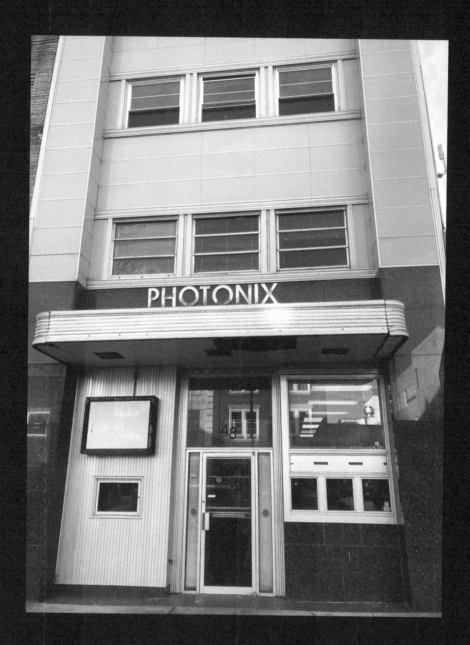

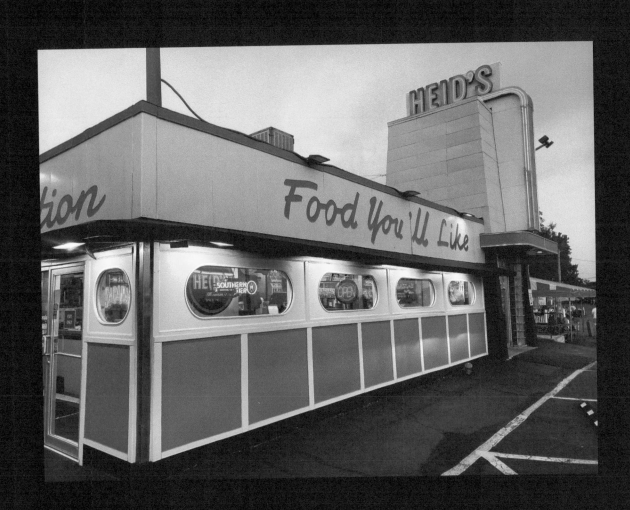

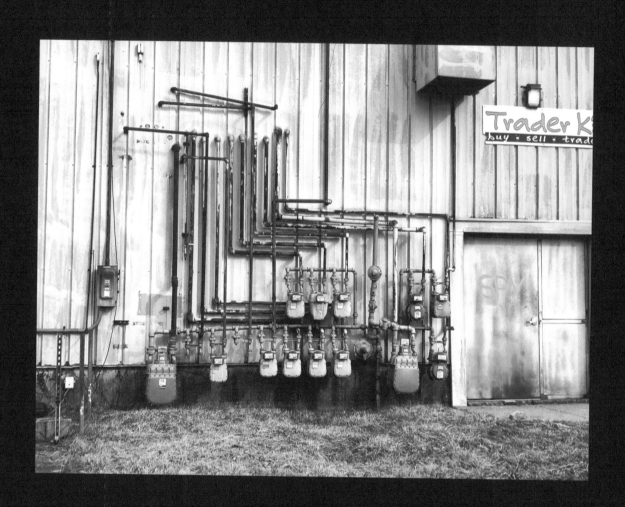

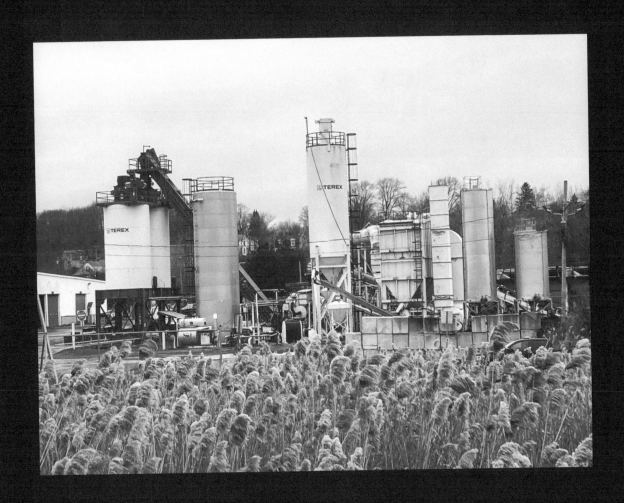

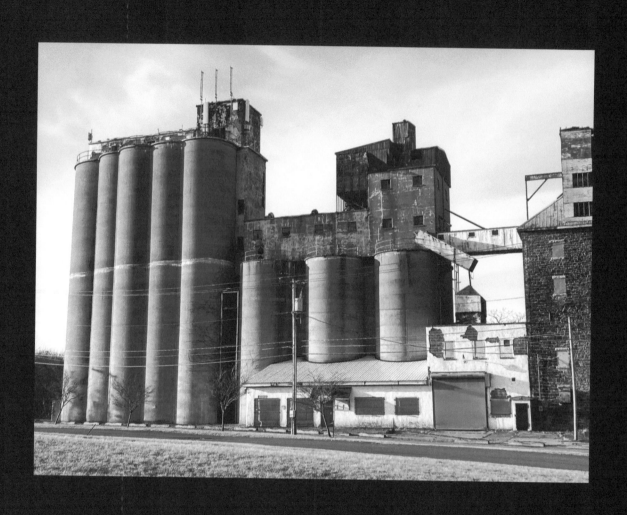

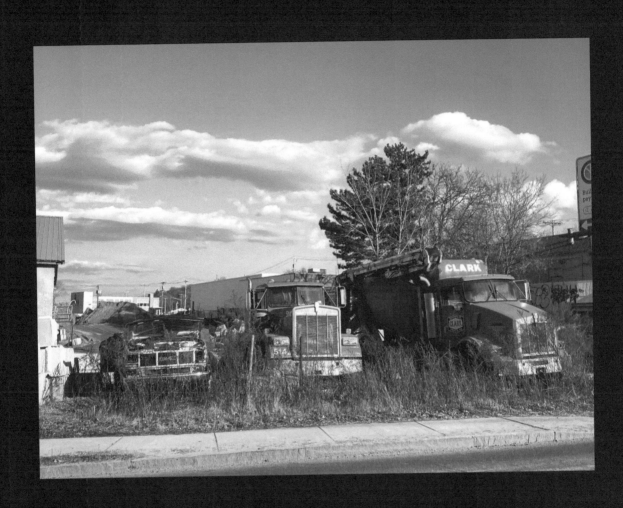

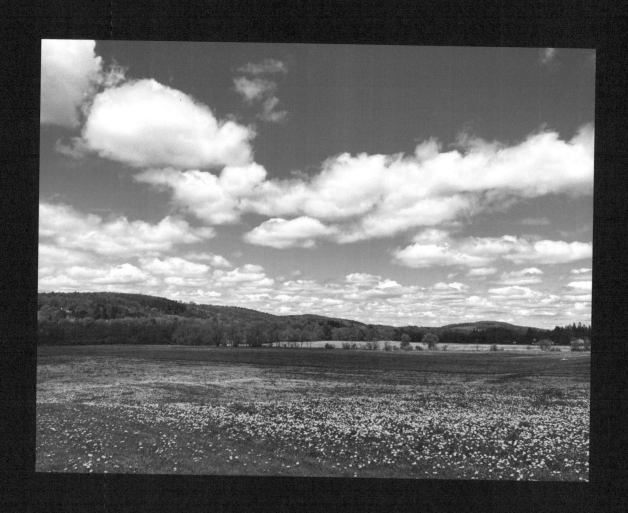

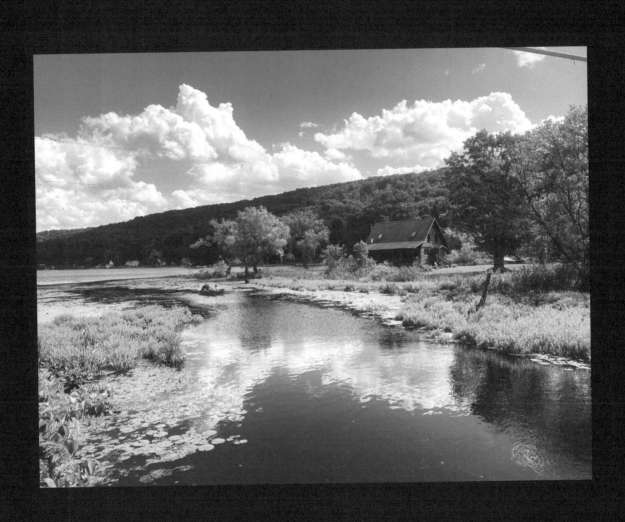

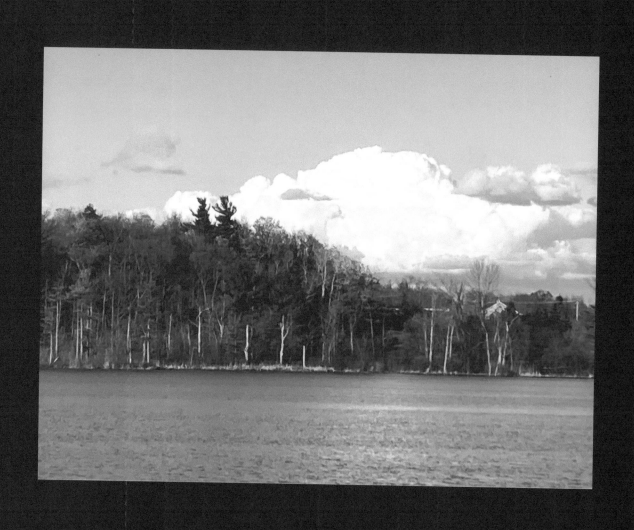

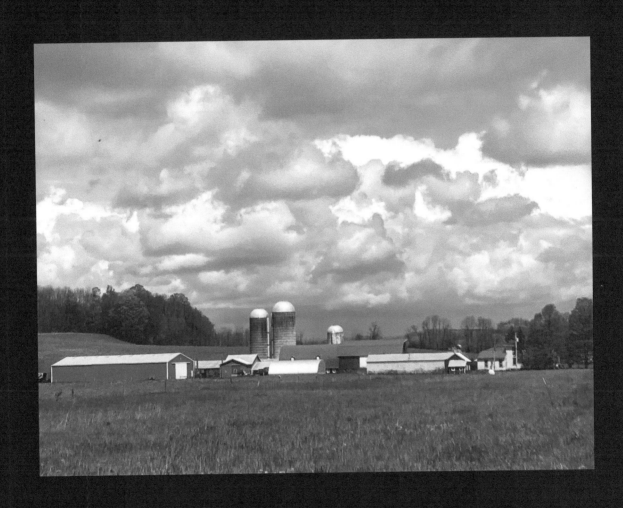

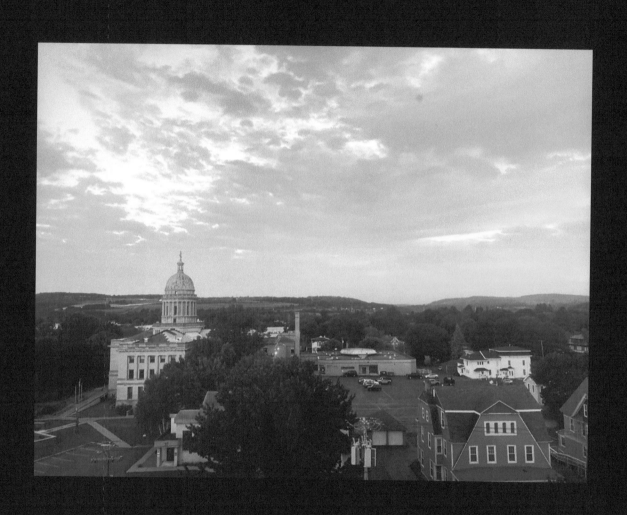

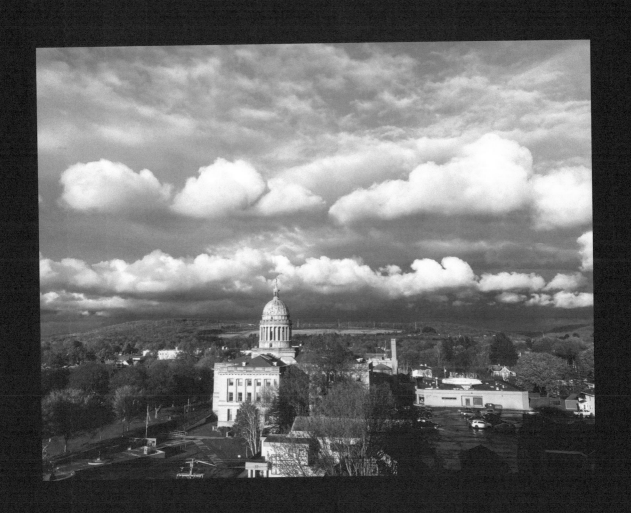

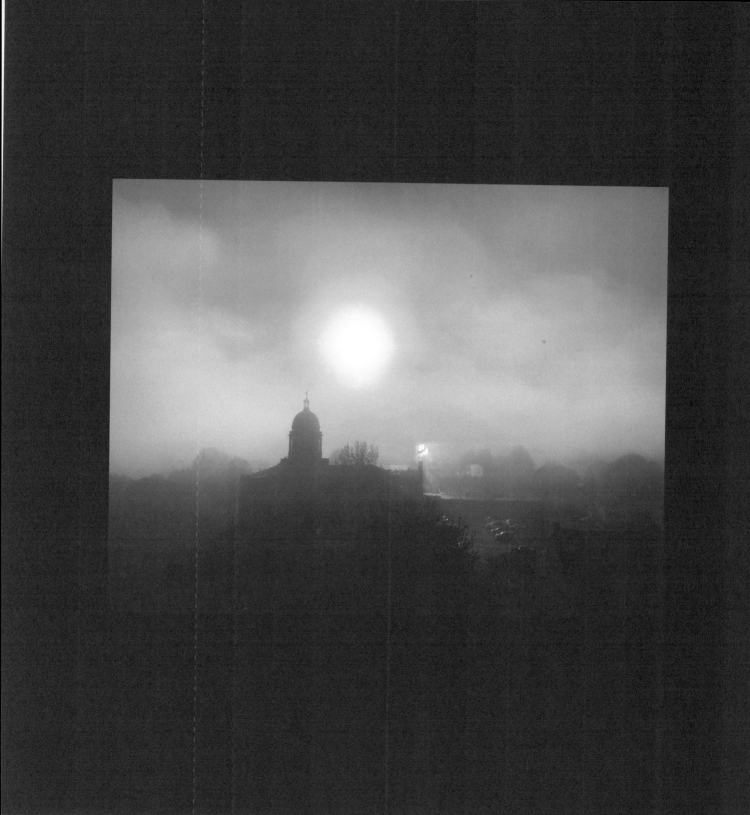

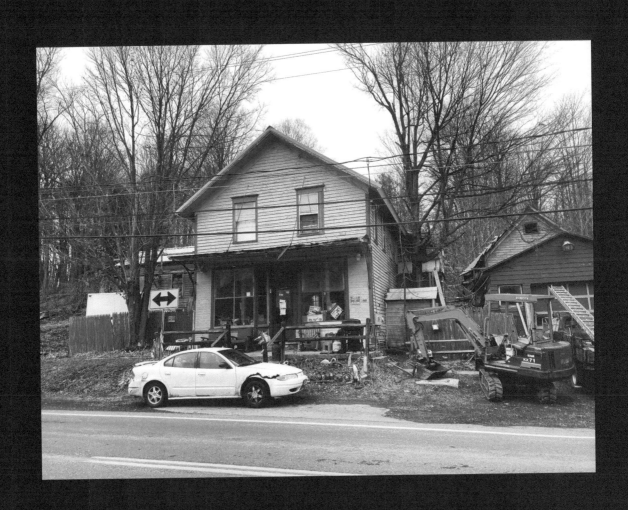

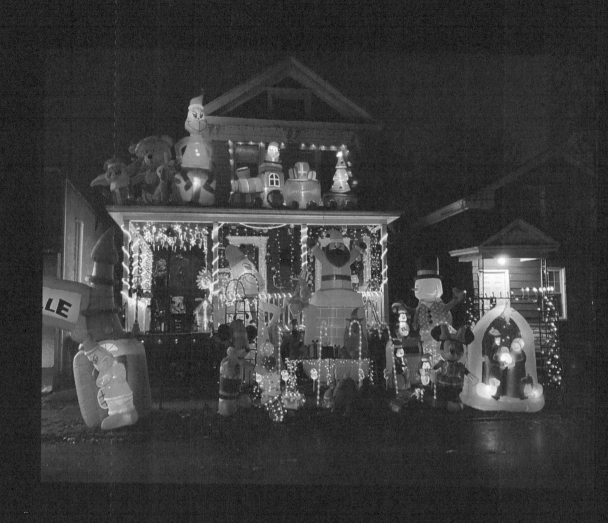

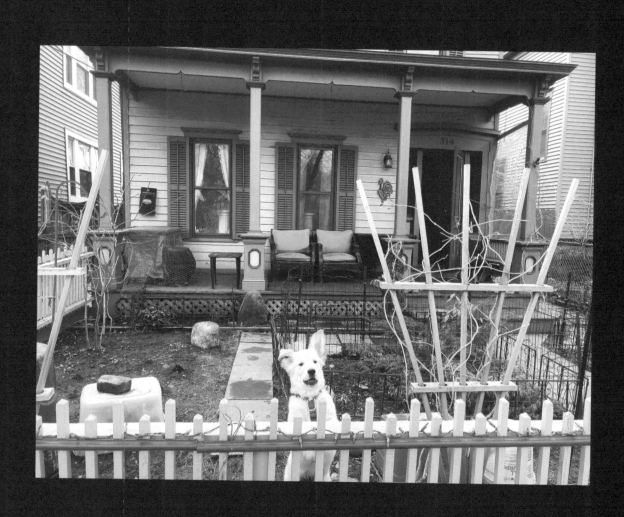

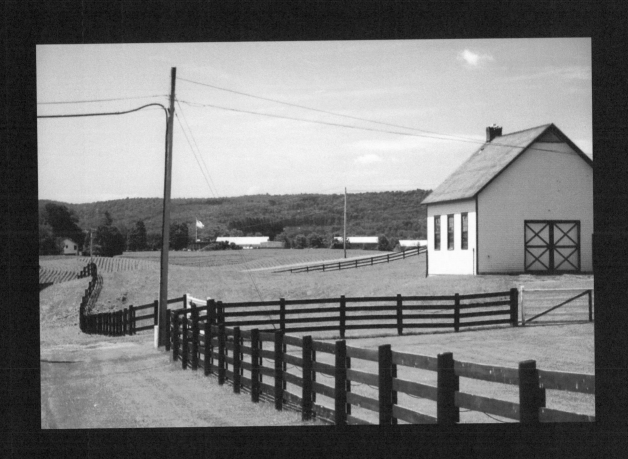

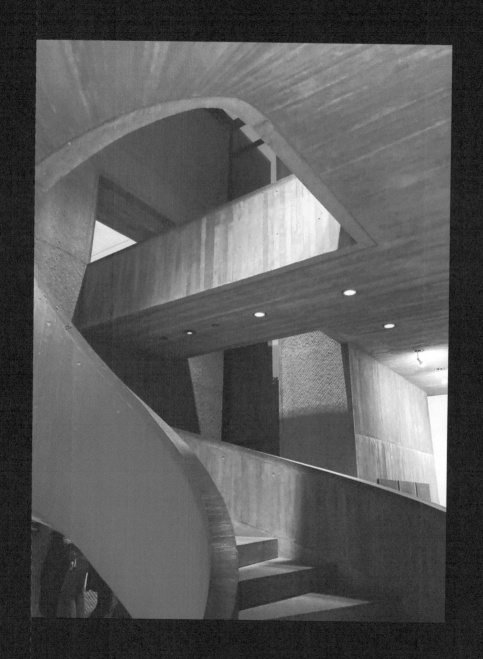

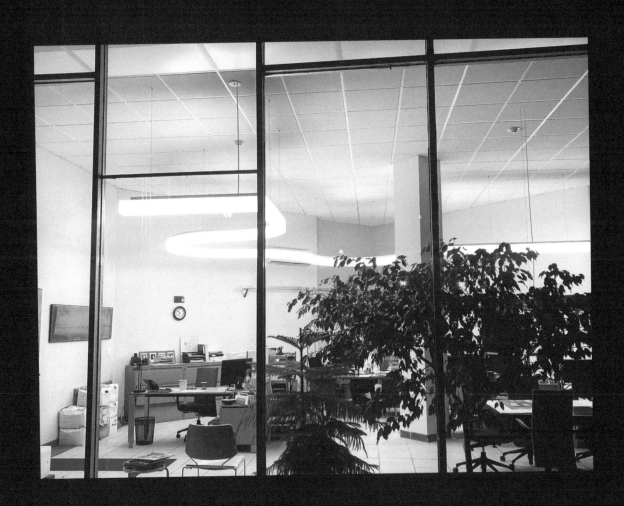

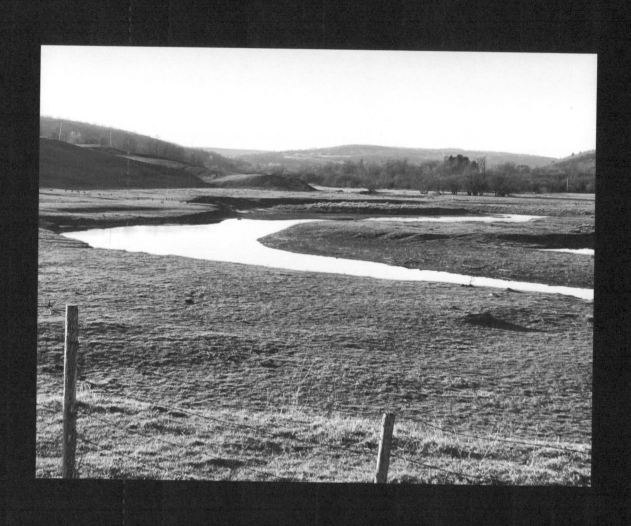

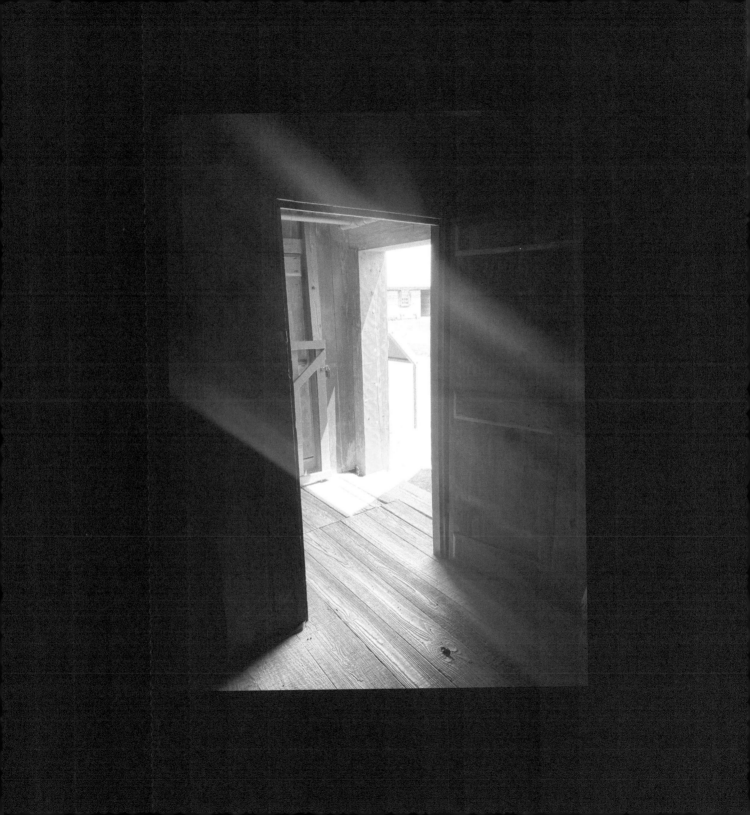

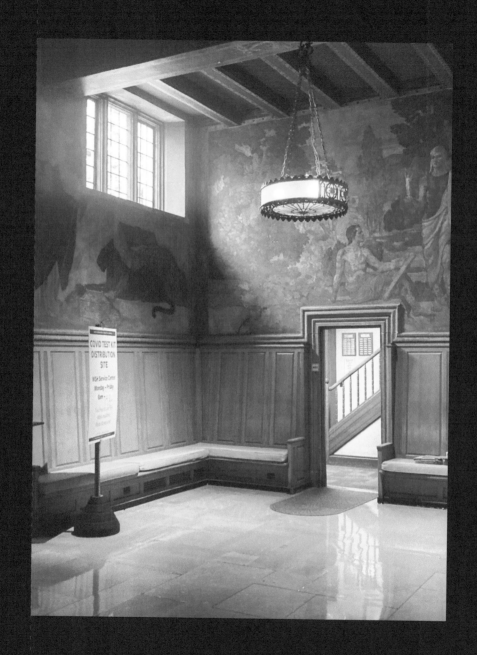

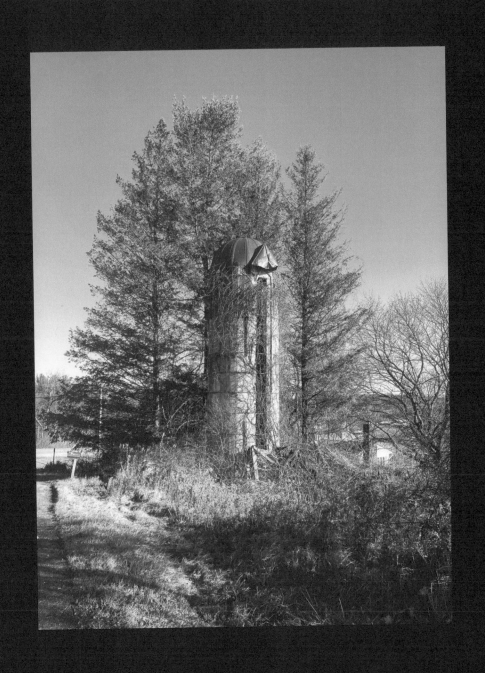

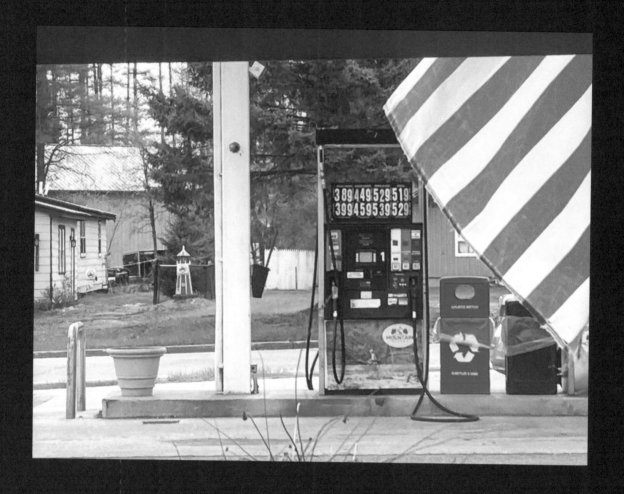

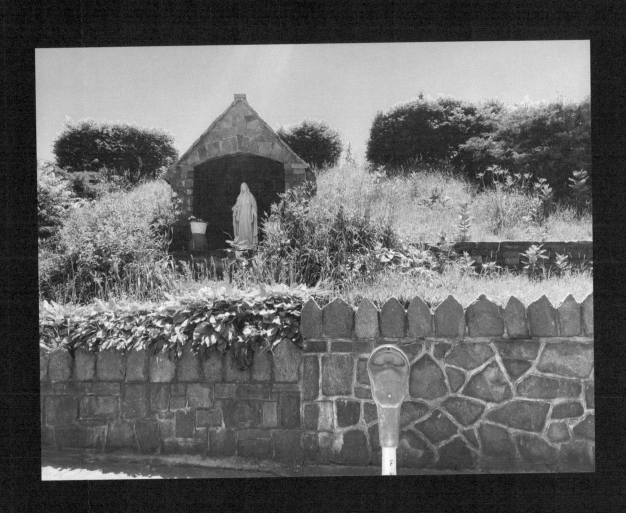

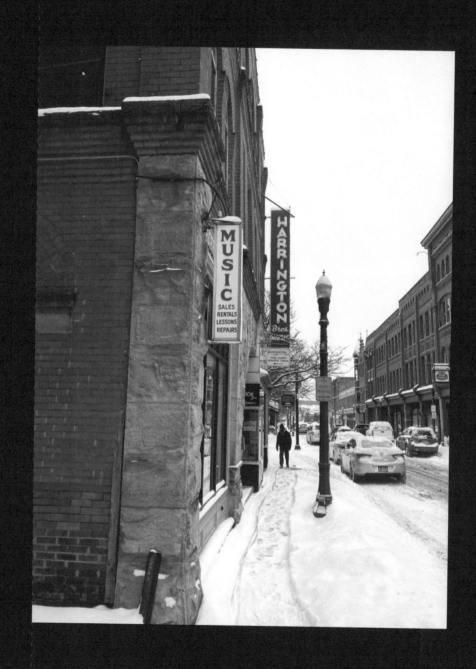

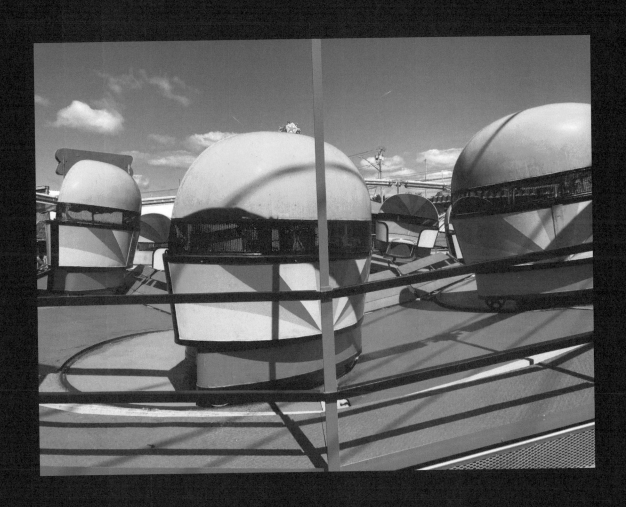

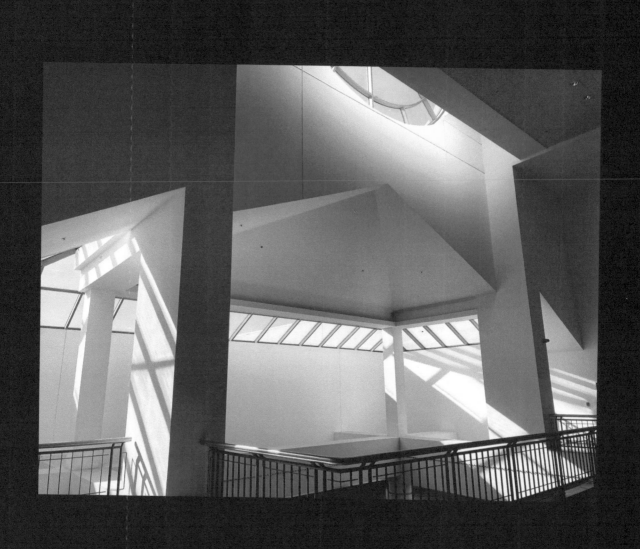

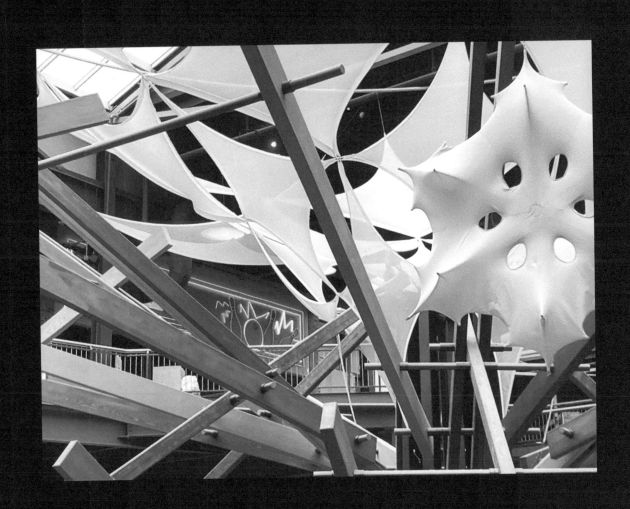

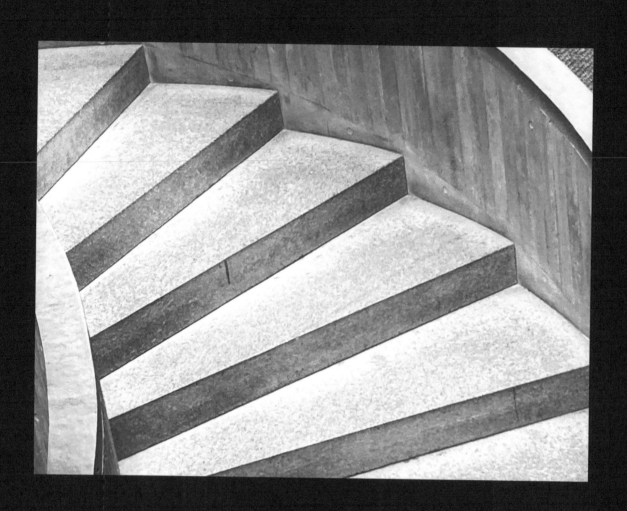

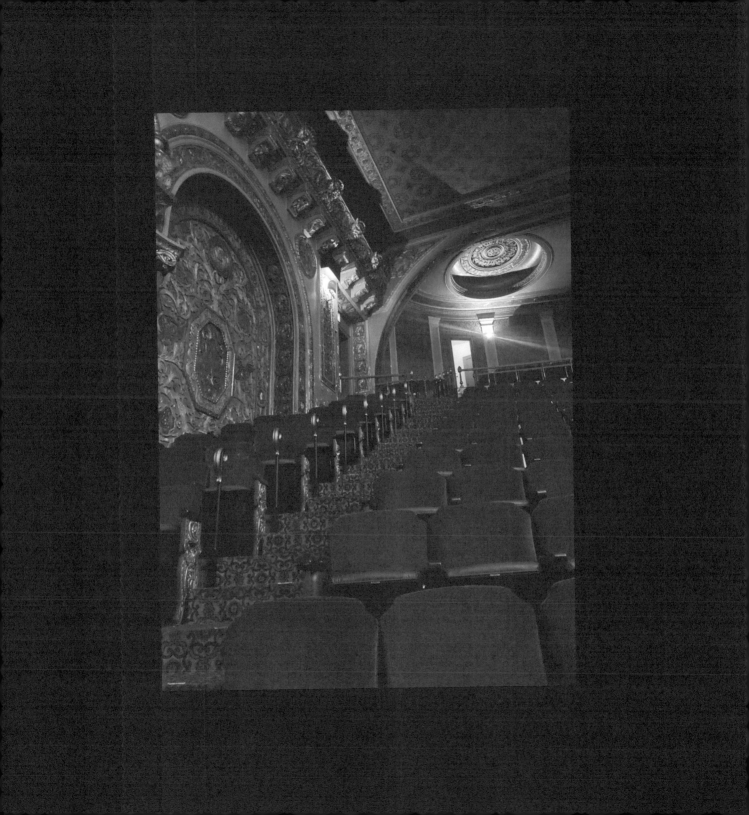

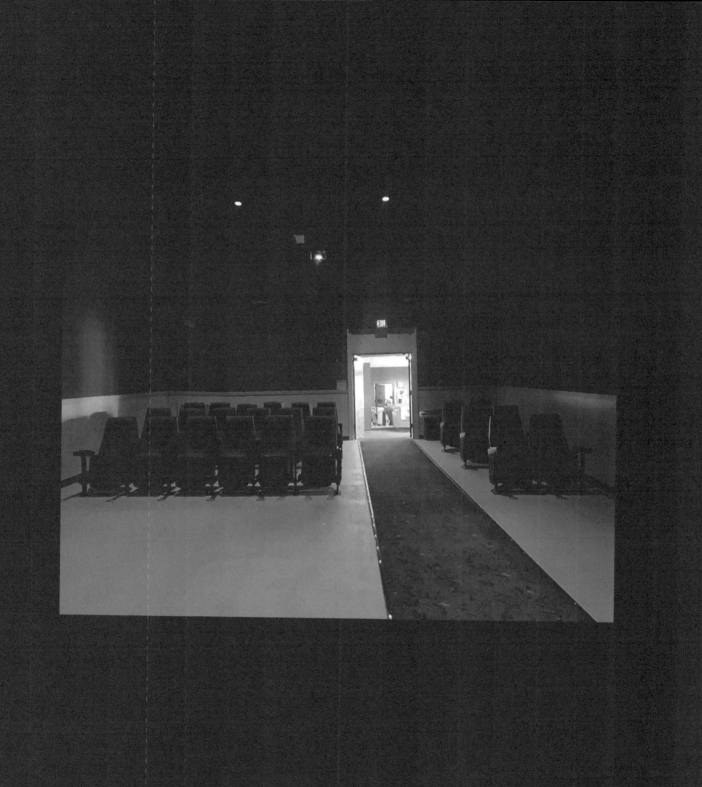

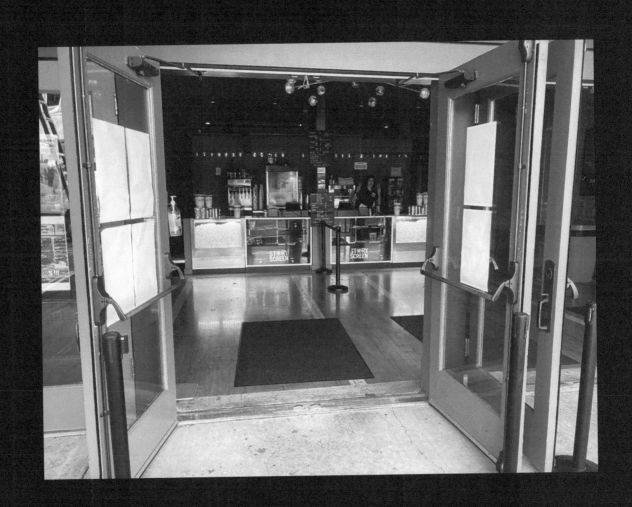

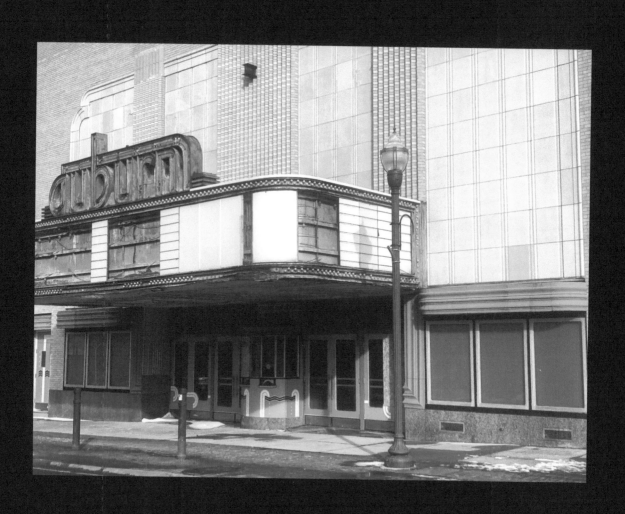

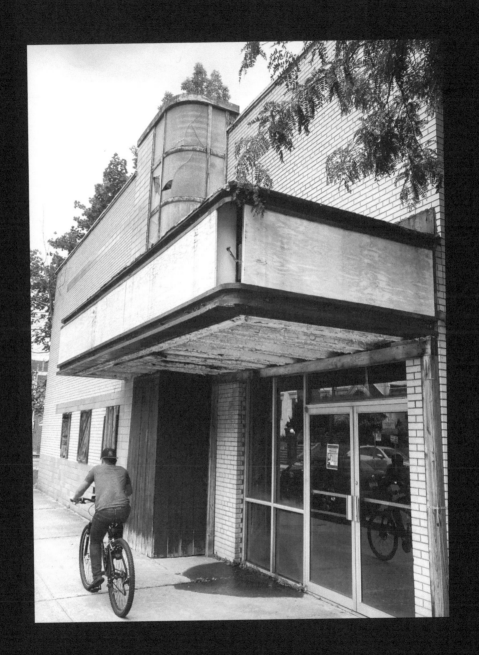

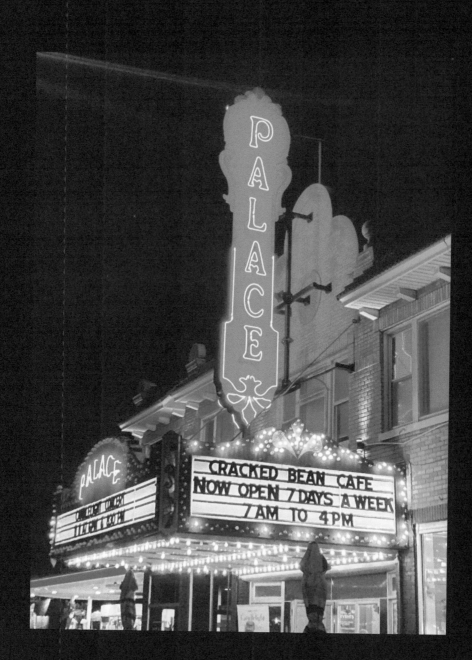

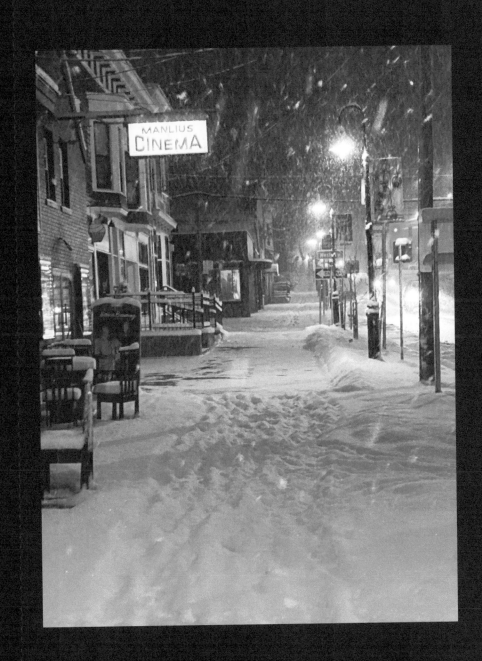

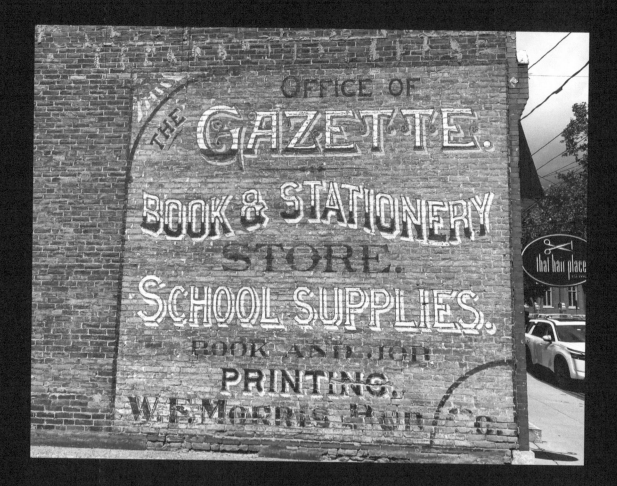

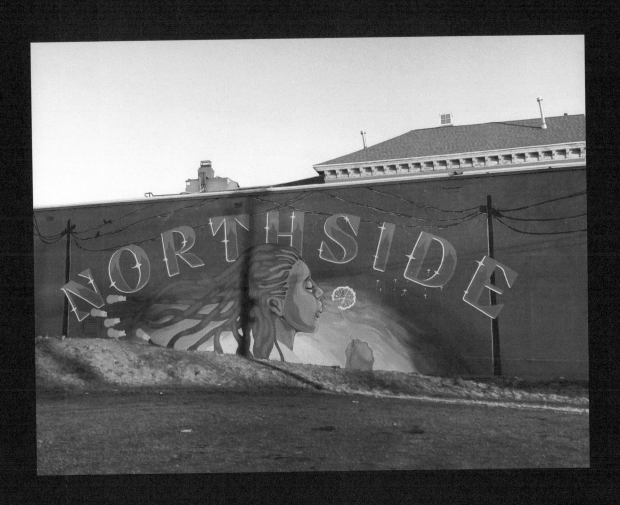

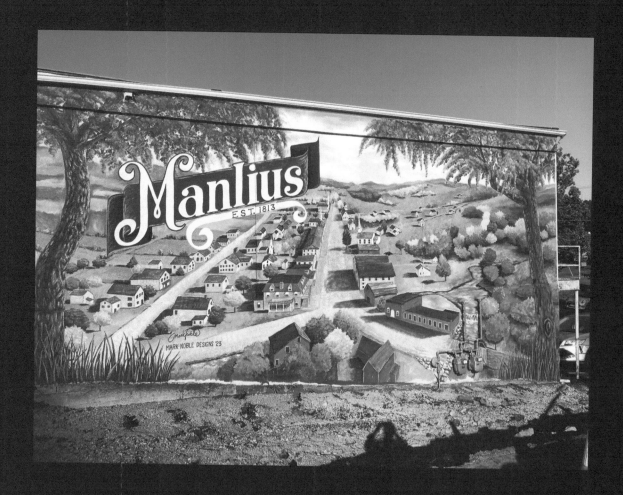

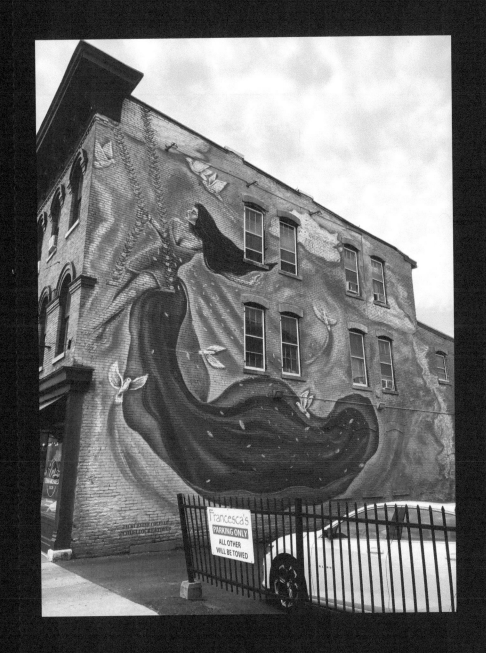

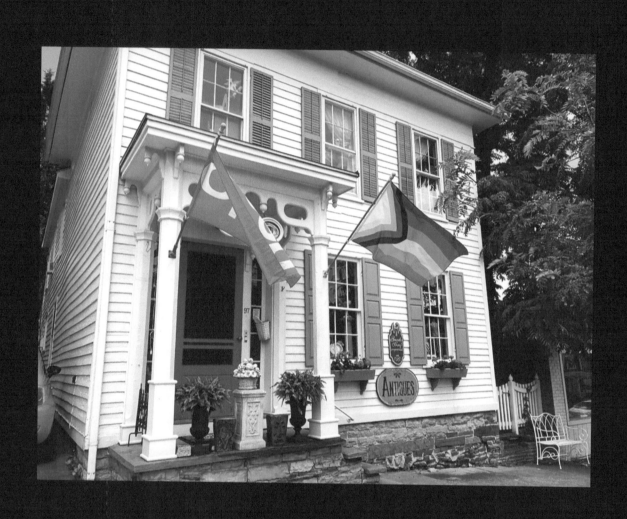

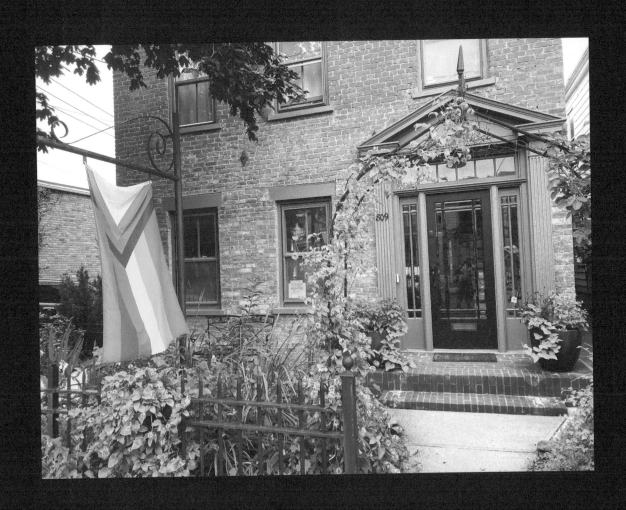

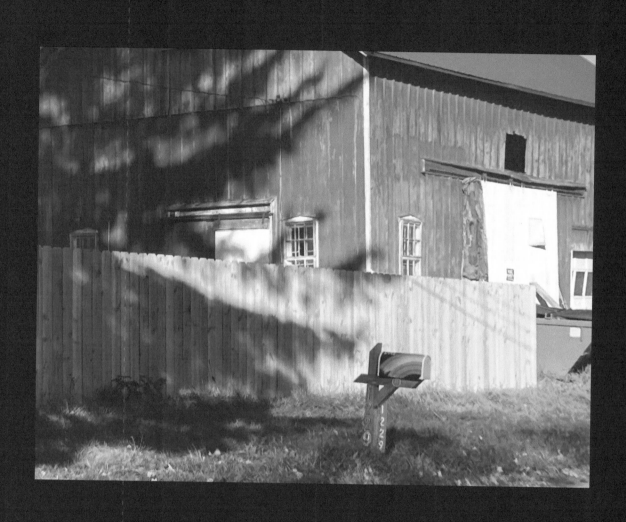

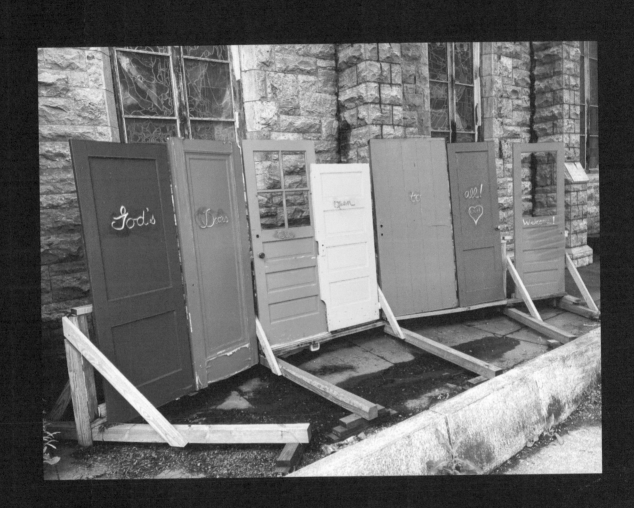

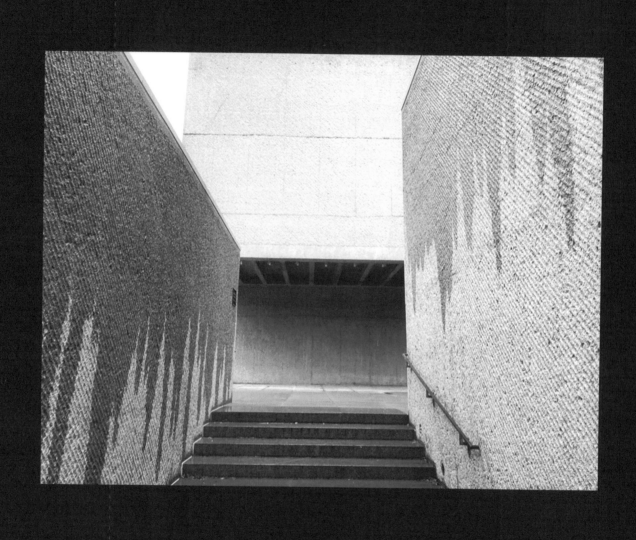

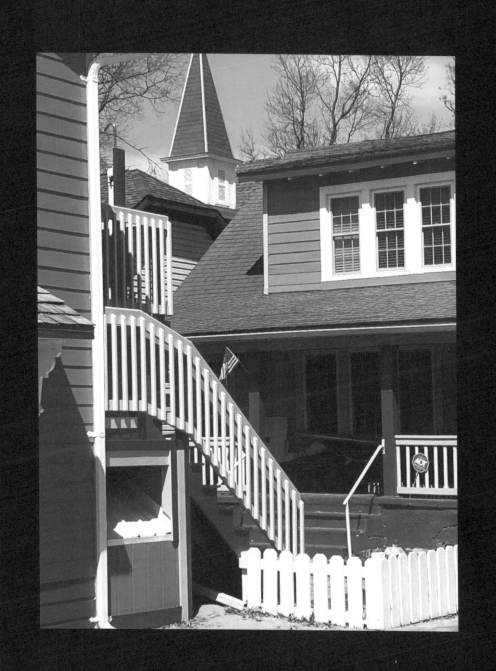

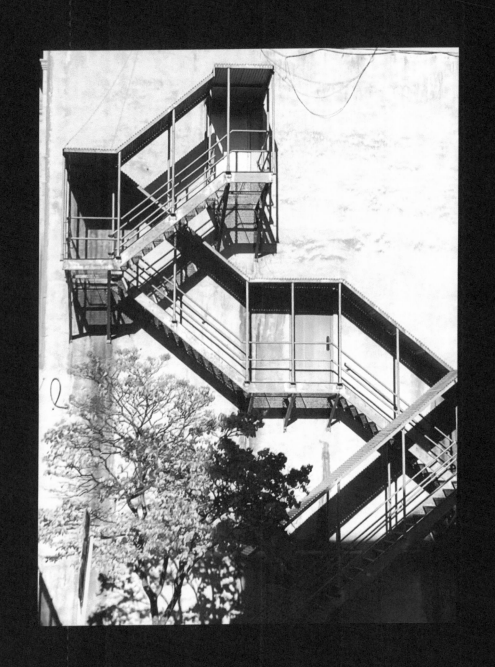

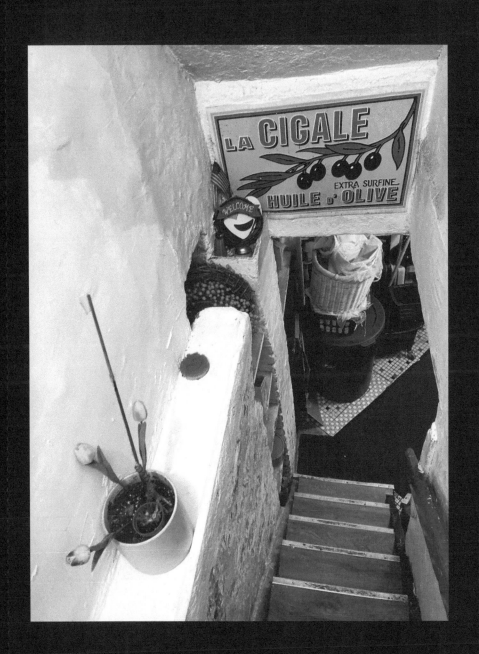

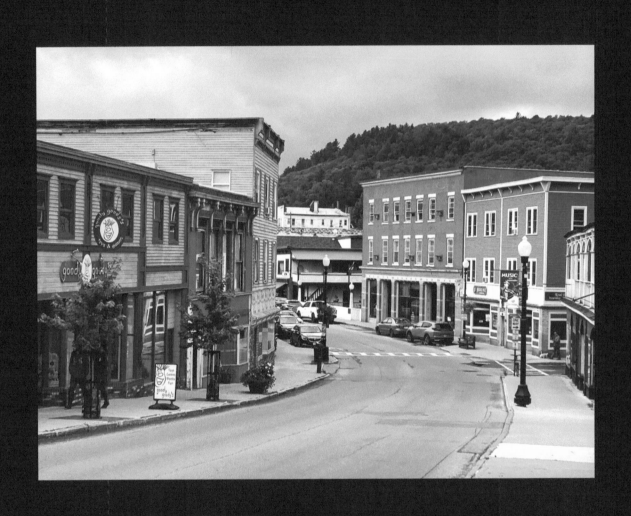

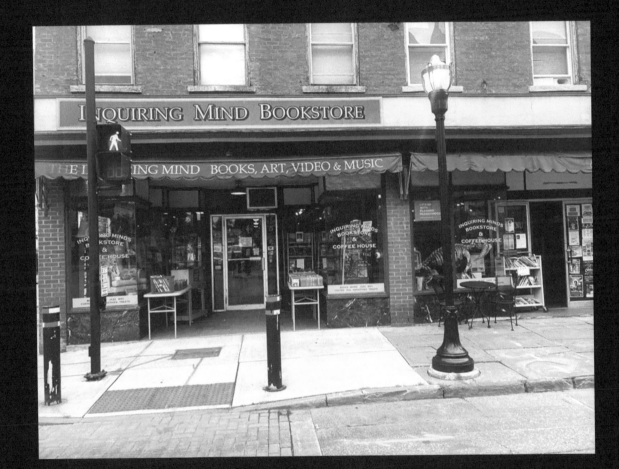

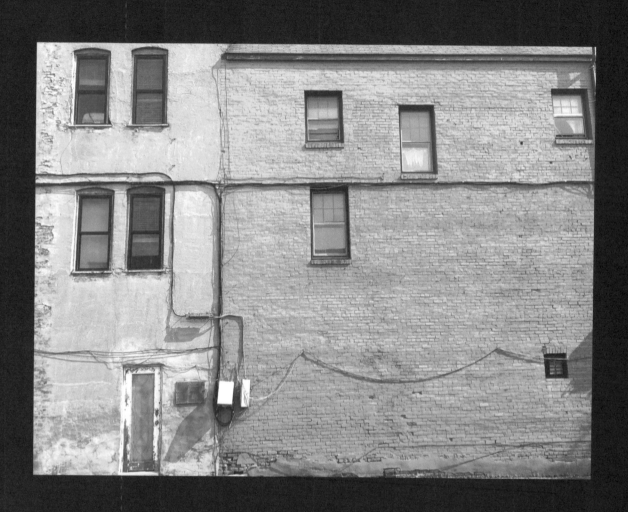

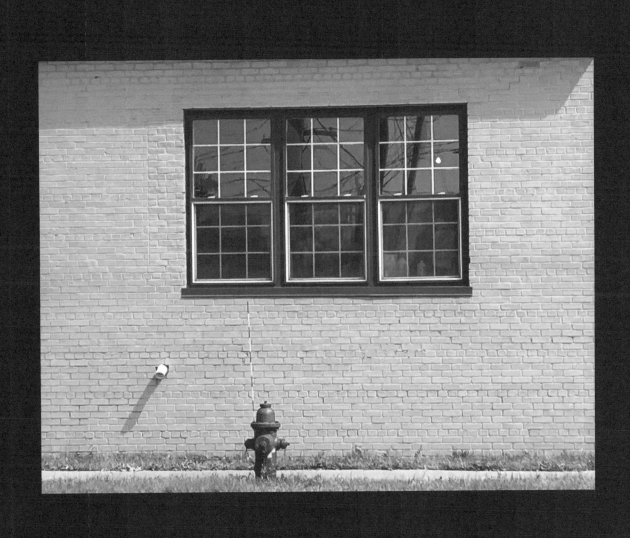

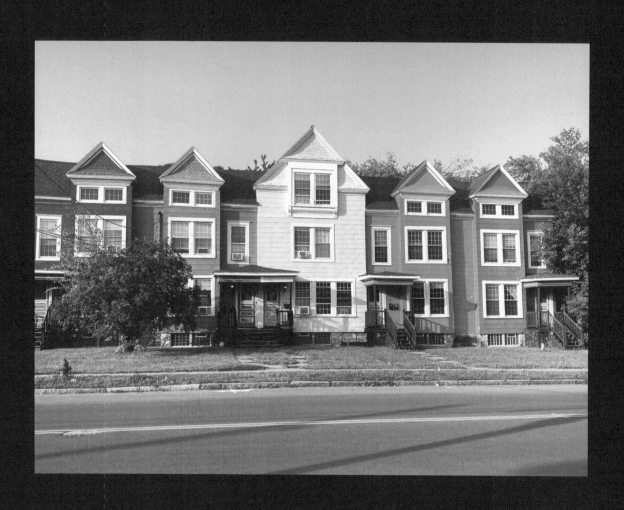

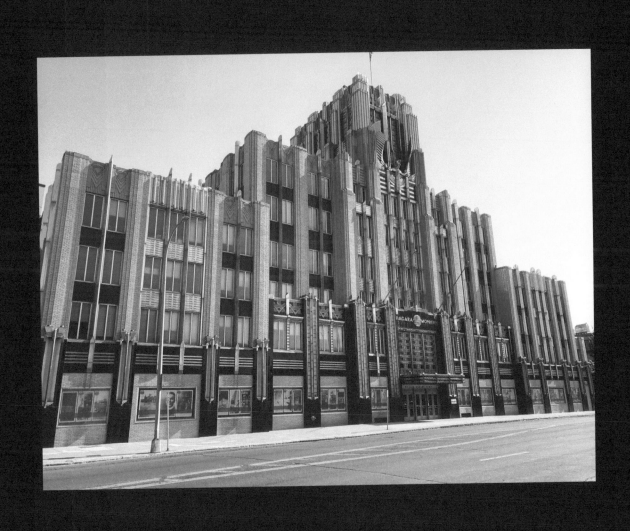

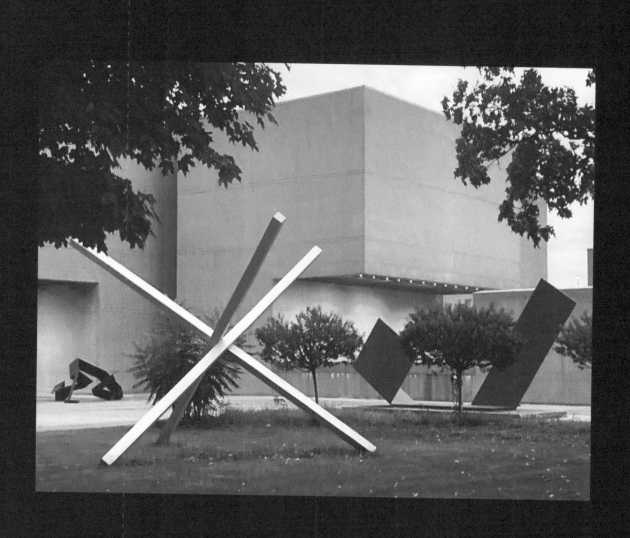

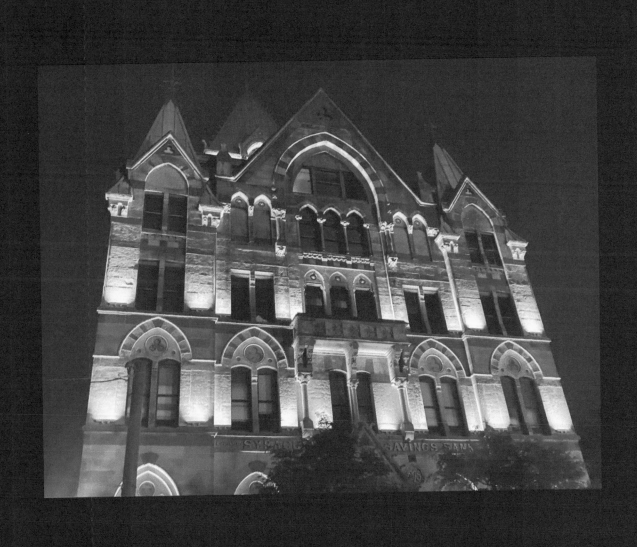

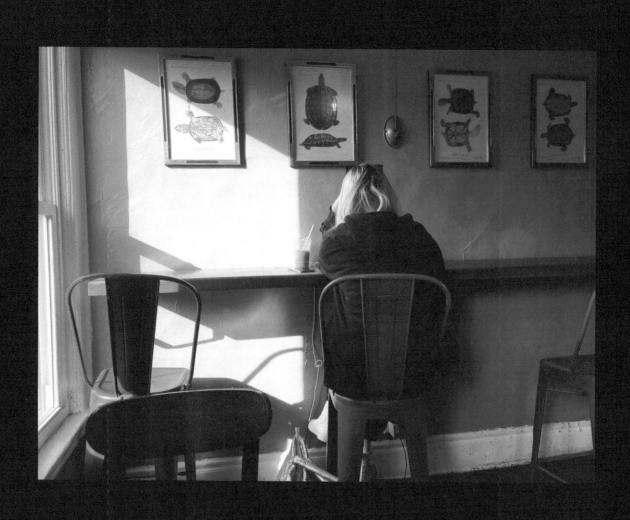

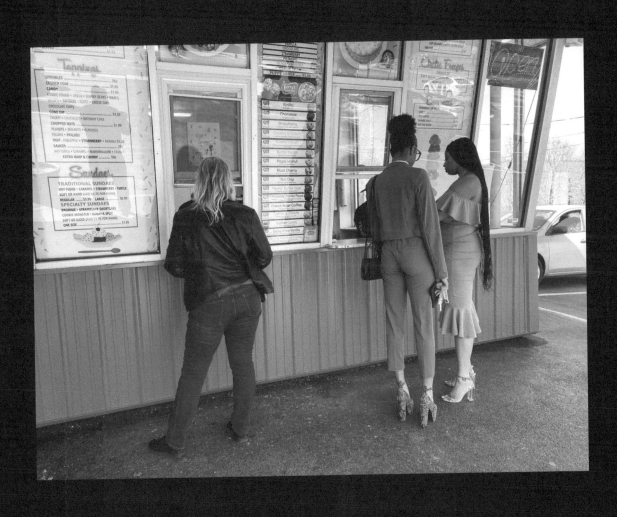

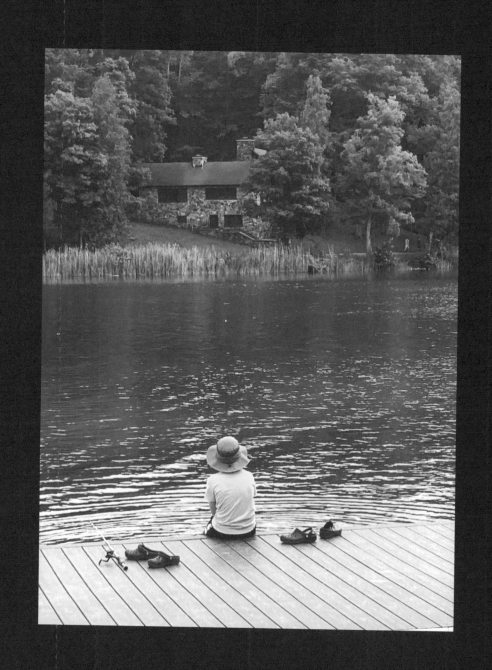

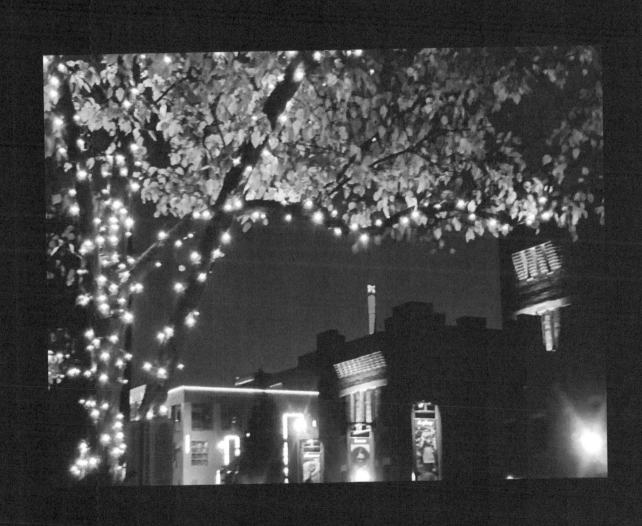

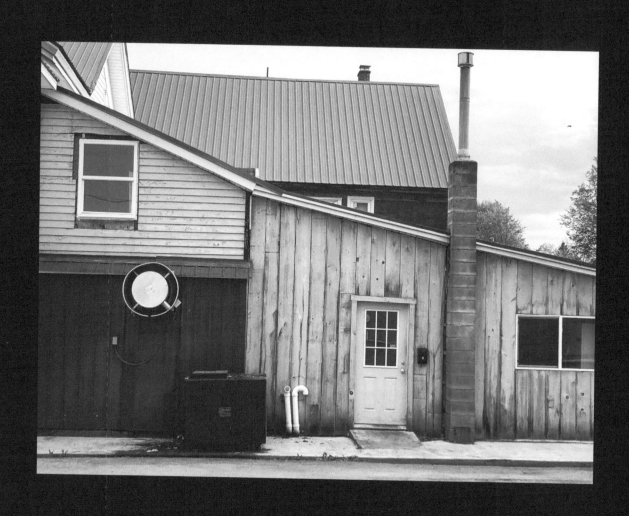

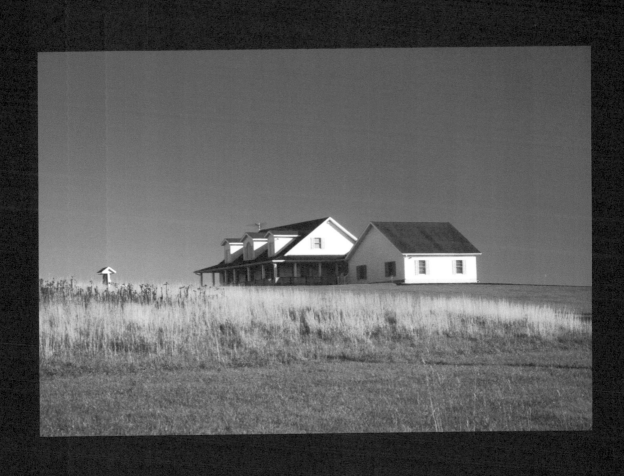

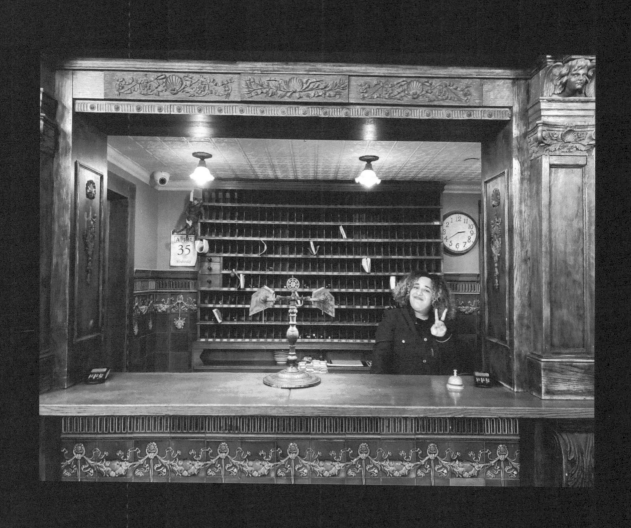

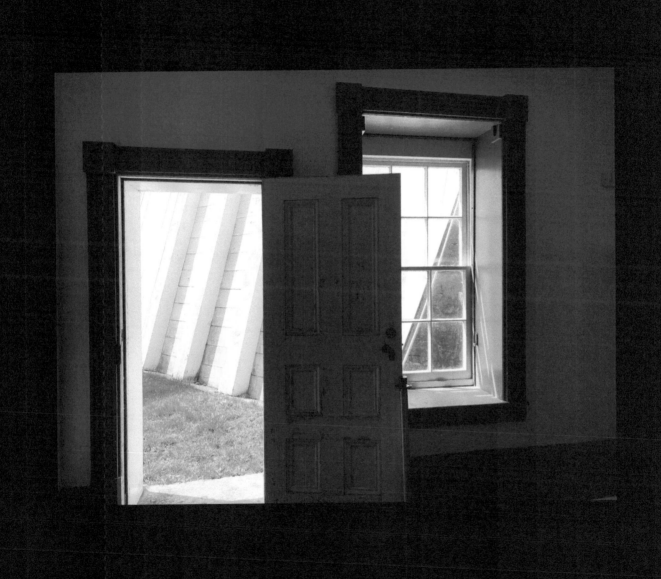